PRACTICAL POTTERY

PRACTICAL POTTERY

A Complete Guide to Getting Started in Making
Beautiful & Functional Bowls, Plates, Vases
& More on the Wheel

SUS BORGBJERG & SUSAN LIEBE

SCHIFFER
CRAFT
4880 Lower Valley Road • Atglen, PA 19310

Table of Contents

Preface

Imagine setting your table with plates and dishes that you designed and threw—or drinking coffee from a cup you created.

Interest in handwork, handicrafts, and ceramics has blossomed, and you can join the party. Working with clay is sensuous and tactile and can be absolutely meditative. The feeling of the clay in your hands, focusing, designing, and throwing, endows your days with peace and an immersion into the everyday.

It doesn't matter whether this is a new hobby for you or you've already tried your hand at clay work; you can experiment with your own ceramics and note the satisfaction even with your first crooked cup or vase—perfect or not perfect, always unique.

Sus and Susan met during our time at Denmark's Design School, and since then we've cocreated. Sus is a graphic designer who loves to have her fingers in the clay and has learned how to throw. Susan is a ceramicist who has long had in mind a how-to book on throwing for beginners.

Now, we have created this book together to inspire everyone who wants to learn how to make pottery, with simple techniques and beginner tips.

Practical Pottery is visual and takes you through all the steps in the sequence with text and photos—from the moment when you sit with a soft lump of clay in front of you; until you knead, throw, fire, and glaze; until you stand proud with your finished cup or bowl in your hands.

We hope this book will give you the joy of throwing and creating ceramics so that, one day, you can cover your whole table with your own unique designs of plates, cups, bowls, and vases with shapes, colors, and surfaces, all chosen after your own taste.

Best wishes for pleasurable throwing!

Sus & Susan

An Overview of the Process

In this book, we'll take you through the sequence, from your dreams of making your own pottery to throwing and, finally, standing with your own set. You don't need to have any previous experience to get going. Everyone can make pottery, and everyone can learn how to throw.

Throwing with clay on a wheel is a simple way to make cups, bowls, and ceramics. You can learn with a few simple techniques and a little practice.

First, there is centering—getting the clay to sit centered on the wheel for starting is one of the hardest things to learn. Have patience and you'll succeed. Once you conquer centering, the rest of the process is much simpler, and you'll be able to throw most projects.

You'll quickly go through the process step by step, from drawing your first sketches until you have the clay in your hands and knead, throw, fire, and glaze.

We'll go through the primary techniques that you will use to learn how to throw a cup, a bowl, a plate, a pitcher, and a vase, as well as all the other details for successful results.

1 **Visualize what you want to throw.**
If you have a few ideas about what you want to make, a really good way of beginning is to draw them in a sketchbook, visualizing your thoughts, colors, and inspiration.

2 **Choose the type of clay.**
Almost all types of clay are usable for throwing, except for clay with a lot of chamotte or firesand (alumina calcined) in it, because it is hard on the hands.

3 **An overview of tools and accessories.**
We have chosen the tools you will need most for throwing and making pottery.

4 **Kneading clay.**
We go through all the kneading techniques so there won't be any air in the clay.

5 **Centering the clay.**
Centering is only a small part of the process, but it is the most important when you are learning how to throw.

6 **Throwing a cup, bowl, plate, pitcher, or vase.**
We will go through the steps for throwing a cup, then a bowl, a large plate, a pitcher, and a vase.

7 **Adding a handle.**
We show how you can make and attach a handle onto a cup or a pitcher.

8 **Cutting off.**
When your pieces are dry, you can cut each off at the bottom for a fine base.

9 **Adding your signature.**
Draw or write your name at the bottom so that people can identify
your work.

10 **Choosing colors and cuts.**
If desired, to paint or decorate your subject with colors.

11 **Drying the clay.**
Control the drying process so your clay dries completely and you
avoid cracks.

12 **Firing the clay for the first time.**
The clay acquires its hardness and turns into ceramic when it is fired for
the first time. Then you can glaze it. You can also decorate it in this stage.

13 **Choosing the glaze and glazing the clay.**
We show you how to glaze your items.

14 **Firing the clay a second time.**
Final firing before your turned works can be removed from the kiln and
put into use.

15 **Enjoy your tableware.**
Pour coffee into the cup and enjoy your work.

snoet hank

flettet hank

string

Visualize What You Want to Throw

Making pottery and learning how to throw are parts of a beautiful and creative process. You can create a sea of expressions in clay, and you can experiment endlessly with shapes and colors, surfaces, and functions.

The creative process has already begun once you become inspired to make something. It could be at an exhibition you've seen, an art book, or something in a magazine. Let yourself be inspired by the visual and the sensual around you and think about how you can use it in your creative process and in your work.

What, for example, should a cup look like? Should it be thin and fine or rustic? What should the surface feel like? Should it be a single color and plain, or should it have lots of colors? What will you put into the cup? What will it feel like to drink out of and to hold?

Use a sketchbook to visualize your ideas. Use colors, materials, and surfaces to illustrate your ideas. Write down your thoughts and considerations. When you look back into your sketchbook, you can find forgotten ideas that simply must be quickly transformed into clay once you have more practice at throwing and more experience with clay.

Use Pinterest to collect inspiration. Analyze experiments and save tutorials on techniques you want to try some day.

Take your ideas and sketches with you to your workshop and try them out in clay. Make clay samples and color samples and experiment. Do not be afraid to make something ugly or crazy. Find your own style and your own design language, while you practice and develop with clay.

Go Out and Get Inspired

If you want to get out of your studio and see ceramics, we can recommend these museums:

American Museum of Ceramic Art—
Pomona, California

Exhibitions and programming at AMOCA aim to increase the aesthetic appreciation of clay as an art form. AMOCA provides clay enthusiasts with encouragement, camaraderie, and exhibition opportunity.

Alfred Ceramic Art Museum—*Alfred, New York*

The Alfred Ceramic Art Museum at Alfred University, a research and teaching facility, houses nearly 8,000 ceramic objects ranging from small pottery shards recovered from ancient civilizations to modern and contemporary ceramic art.

Arizona State University Ceramics Research Center & Archive—*Tempe, Arizona*

The ASU Ceramics Research Center provides access to the collection of more than 3,800 objects and includes a gallery space, an archive, a library, a classroom, and more.

Museum of Ceramics—*East Liverpool, Ohio*

The Museum of Ceramics, housed in the former East Liverpool Post Office, is a ceramics museum that contains an extensive collection of ceramic wares produced in and around East Liverpool, a city known as "America's Crockery City" and "the Pottery Capital of the Nation."

The Museum of American Pottery—
Creedmoor, North Carolina

The Museum of American Pottery honors family and studio potters who have made a significant contribution to the arts; maintains a library of books, magazines, articles, videos, and photos of pottery and potters from 1700 to the present; provides funds for research and opportunities for pottery students to further their studies; and ensures that examples of work by these potters are preserved for future generations.

Choosing Clay

Clay and ceramics signify all types of clay. When clay is to be fired, it becomes a ceramic. The first firing is called the bisque firing (pre-annealing) and is done at about 1,742°F (950°C). The second firing, the glaze firing, is done at varied temperatures depending on the type of clay. Earthenware is fired at the lowest temperature, and ceramic clay can tolerate the highest temperature.

The primary types of clay are earthenware, stoneware, and porcelain. Clay is a fine-grained soil type consisting of clay minerals. It can be as white as porcelain or be found in all shades of brown, gray, red, and yellow, depending on the iron content and other impurities in the clay.

In this book, we have chosen to use various types of clay for each item to show some of the different looks, colors, and qualities that clay has.

Earthenware
Approximately 1,832°F–2,012°F (1,000°C–1,100°C)

Earthenware is low-firing clay. That is to say, the clay is fired at a lower temperature than stoneware and porcelain. Therefore, its energy cost is cheaper for production, but at the same time, it is also less durable.

Clay is not watertight after firing. If it will be used for cups or flowerpots, it must be glazed to make it watertight.

Earthenware can have many colors. It might be white, yellow, black, or red. The most common earthenware color is red, which is used for flowerpots and Christmas decorations.

Earthenware is very suitable for decorative pieces because the colors do not burn away when the clay is fired up to about 1,832°F–2,012°F (1,000°C–1,100°C).

It is important that earthenware is not fired at a higher temperature than recommended. If it accidentally goes into the kiln set for a stoneware firing of 2,192°F–2,372°F (1,200°C–1,300°C), the earthenware will melt.

Stoneware

Approximately 2,192°F–2,372°F (1,200°C–1,300°C)

Stoneware is a high-firing clay. Its maximum temperature can vary, but it can become watertight and cold-sintered (compressed without melting) when it is fired. It's still best to glaze it for reasons of hygiene if it will be used for food.

This type of clay comes in many different colors and versions. It can be gray, red, brown, or black. It can have one color when it is raw and another color after firing. It can also feel very different.

Stoneware with chamotte (very small grains of fired clay) can feel very rough. It can scratch and be very hard on your hands when throwing it. However, it is particularly suitable for modeling because it holds its shape and dries better, and it does not crack easily.

It can also affect the glaze and cause some wild effects. Therefore, it is a good idea to make a little glaze trial before you glaze something you worked on for a long time.

Stoneware is well suited for cups, bowls, and plates as well as small and large shapes. It is dishwasher safe.

Porcelain

Approximately 2,282°F–2,372°F (1,250°C–1,300°C)

Porcelain is a high-firing clay, which makes it strong and durable.

Porcelain is white and almost transparent when it is very thin.

For example, if you make tea-light holders with porcelain, the light will illuminate the clay and it will have a warm, golden tone.

Porcelain also becomes watertight when it has been fired. It is best, though, to glaze it for hygienic reasons if you want to use it for food and drinks. An unglazed mug will become miscolored by coffee or will wear out eventually.

Porcelain is very soft and very elastic to work with. It is especially nice to throw, but it can also be too soft and collapse. It is a good idea to throw quickly and not use too much water when throwing porcelain.

Porcelain items are good for service. The white porcelain is also fine for decoration because the colors are very clear on the white background. However, not all colors will tolerate firing at high temperatures.

Clay can have a certain tendency to "remember," especially if it is bent or bumped during production. If you had a bent rim when the clay was soft and you fixed it, the clay may still move back a little at the rim later in the process.

Other Types of Clay

Besides the prepared types of clay, clay can also be used in other ways. The castings are pulverized earthenware, stoneware, or porcelain, which then has water and liquid added. It is used for casting in molds and is effective when many items of the same model are to be made.

Recycled Materials

If you have leftover clay, you can recycle it. Always remember to keep the different types of clay separated.

The best way to recycle clay is to let the clay dry out completely in a bucket without a lid. When it is bone dry, you can add water and let it loosen up slowly. When the clay is completely loosened and crumbly, you can knead it again. See page 26.

It is important to avoid clay and glaze dust. Quartz and flint particles are damaging to health, so it's particularly important to keep your workplace clean. Do not sweep, since that just swirls the dust around. Use water to clean any surfaces, and avoid grinding completely dry clay.

1

1 Pour the water over the dried clay remnants so that the water covers the clay. When the clay has loosened up, you can move it over onto a heavy piece of plasterboard. In general, the clay is too wet to be kneaded together right away.

2 The plasterboard will absorb water from the clay. When the underside of the clay is firm enough, you can turn the clay around on the board so the other side can also dry. The clay can be kneaded together when it no longer sticks to the plasterboard.

Use "the "cut-and-slap-together" method as explained on page 38. Knead the clay at least 50 times. The clay is kneaded enough when the lines are indistinct and it feels uniform.

Because clay is an organic material, it can begin to deteriorate over time. It can smell and change color, but, usually, that doesn't mean anything for the clay. It can be dried out and the discoloration will disappear later during firing.

An Overview of Tools and Accessories

Metal and nylon cutting wires (1)

Sponge (2)

Plastic rib/scraper (3)

Potter's needle (4)

Flat modeling tool (5)

Craft knife (6)

Ruler (7)

Sponge stick (8)

Modeling stick (9)

Steel rib/scraper (10)

Brush (11)

Loop tool (12)

Metal blade (13)

Apron

Slip

Brushes

Large bowl of water

Large mixing bowl

Tub

Pitcher

Rags

Plastic bags

Rolling pin

Pencil for ceramics

Stamp

Turntable

Modeling (rotating) stand

Plasterboard

Plasterboard plates

Dust mask

Waterproof sanding paper

Glaze

Ceramic kiln

Kiln wash

Kiln supports

Cones

Rib or Scraper

A rib is a tool you can use for many processes. Ribs are available in metal and soft or hard plastics and in various shapes. In this book, we use a hard plastic rib. You can also use a plastic card to make your own rib, cutting it to a shape that suits you.

Cutting Wire

A cutting wire is usually metal, good for cutting through large pieces of clay. We recommend a finer cutting cord when we cut thrown items off the wheel. We prefer using a nylon cord because it makes a finer cut and is easier to hold all the way down to the wheel surface.

Metal Blade

A metal blade is a strong piece of metal used for scraping hard glaze residue off the kiln tray or off the bases of your pieces if they sat a little firmly after firing. Some sharp bits might jump off your piece, so wear safety glasses when you are removing the residue.

Sponge Stick

A sponge stick is a stick with a sponge at one end. These are useful when you have thrown a piece with a narrow neck and have dried bits of clay on the base where your hand won't fit down. You can buy these ready-made or make one yourself with a half kitchen sponge attached to a dowel and secured with a rubber band around it.

Slip

Slip is dry clay mixed with water so it becomes soft, thick, and sticky. It functions as a type of glue when you want to attach two things, such as, for example, a handle to a cup. You should always use the same type of clay for the slip as the clay you are throwing. See more on page 125.

Modeling (Rotating) Stand

A modeling stand is a little throwing plate that sits on a table. It's good for setting an item on while you continue to work on it.

Plasterboard Bat

A plasterboard bat is something you use on top of a wheel plate when you, for example, throw plates. It is also perfect for placing thrown items because the plaster absorbs water from the clay.

Plasterboard Plates

Plasterboard plates are available in several varieties. When you knead clay, it is best to use a large plasterboard plate measuring about 2 inches (5 cm), which can absorb a lot of water. Plasterboard plates that are used for building walls are also good for setting pieces on when your items are leather hard and only need to dry.

Dust Mask

A dust mask with a P3 filter protects against the tiny dangerous particles found in glaze powder. Glaze powder is damaging to health when it is inhaled.

Waterproof Sanding Paper

Waterproof sanding paper is a fine-grain sanding paper you can use to sand your fired clay. You need to use water while you sand. It is recommended that you sand the base and other unglazed surfaces with waterproof sanding paper after they have been fired to make the surface smooth and fine.

Ceramic Kiln

If you don't have a ceramic kiln at home, there are studios or craft centers that will fire for you. Check the internet for pottery studios.

Kiln Wash

Kiln wash is a powder you can mix in water and paste over the kiln trays to protect them. The kiln trays should be wiped clean of glaze residue before you load anything on them.

Kiln Supports

Kiln supports are small cylinders that you set at three or four places on each layer so you can build layers up like a layer cake.

Cones

Cones can be used in the kiln if you need to fire to a precise temperature or if you are in doubt about the kiln firing to the same temperature as on the control. The cones melt at specific temperatures. When that happens, you will know precisely what the temperature of the kiln is.

Kneading Clay

Tools and Accessories:
Metal cutting thread
Large thick plasterboard or wood board
Apron

There are several ways to knead clay. We will go through the classic techniques as well as the "cut-and-slap-together" method, as we call it.

Before you start throwing, it's important to knead the clay. Clay should have a uniform consistency, and the air holes must be kneaded out of the clay. If there are any air holes in the clay, it can cause trouble when you throw. Air pockets can also cause the clay to jump when it is being fired.

Use a good, firm, and thick wooden or plasterboard plate for kneading. If you use plasterboard, just remember that it will absorb water from the clay and dry the clay out faster. If the clay is very wet, however, it can be an advantage. You can dampen the plasterboard thoroughly before you begin kneading so it is saturated with water.

When you take the clay out of the bag, it might feel very firm if it has been in the bag for a long time. That doesn't necessarily mean that it lacks moisture, but it should be kneaded at once so moisture can be distributed throughout the clay. If the clay is very hard, it could be because it is too dry and cannot be kneaded. In that case, prick holes in the clay and place it in a bucket of water overnight.

1

Classic Kneading

This method of kneading is suitable for clay that doesn't have to be kneaded very much or if it has first been kneaded in the "cut-and-slap-together" method. It's the most common method for kneading clay, and it's just like kneading bread dough. But, instead of kneading air into dough, you'll want to knead air out of clay.

That means, when you knead clay, you should be careful that it doesn't overlap, which can introduce air holes to the clay.

1 Hold the clay in front of you in a collected clump and press it down against the surface with the palms of your hands. Use your body weight to spare your arms.

2 Rotate the clay a quarter turn toward you and repeat. Hold the clay together and beat it evenly as you work. The clay should look as if it has a lot of layers as you knead it. When the clay feels soft and uniform, it has been kneaded enough. Finish by patting the clay so it has a smooth and even surface.

Cut-and-Slap-Together Kneading

This kneading technique is suitable for all types of clay. It's a good way to start when the clay is very uneven in consistency or if there are clumps and air in the clay. It beats the air out of the clay and distributes the solids and softens the clay.

1 Take a clump of clay weighing about 8.8 pounds (4 kg). You can divide it up into smaller amounts later when it has been kneaded somewhat. Begin by shaping the clay so it is rounded and has an even surface. Throw the clay down (preferably with a hard throw) onto your work surface.

2 With your cutting wire under the clay, at the center of the clump, cut the clay from the bottom up.

3 Take the first section of the clay up, turn it 180 degrees, and slap it down on the back section, so the two surfaces lie evenly over each other.

4 There might be a mass of horizontal uneven lines in the two areas where it was beaten together. That is because the clay is very uneven in consistency. They will align the more you knead the clay and repeat this process. Repeat the process 5–10 times, depending on the clay. The clay is kneaded enough when there are no large visible uneven lines in the clay.

There are other methods for kneading clay, but the two we recommend here are both easy and effective.

1

2

3

4

Dividing Clay into Sections

When you have kneaded the clay, you can divide it up into smaller clumps. Roll the clay into large "sausages" about 3⅛–4 inches (8–10 cm) in diameter and mark the pieces you will use on the sausage. Turn the pieces and shape the clay into balls that are uniform in surface and shape. Avoid introducing air into the balls as you prepare them.

It's best to begin by throwing something that isn't too big. We recommend a piece the size of an orange. That is enough to make a bowl. Cover the clay balls with plastic to maintain their moisture until you use them.

Approximate sizes for dividing clay into segments

Cup: 0.55 lb. (250 g), peach size

Bowl: 0.88 lb. (400 g), orange size

Plate: 2.4 lbs. (1,100 g), like a small honeydew melon

Pitcher: 1.98 lbs. (900 g), grapefruit size

Vase: 1.98 lbs. (900 g), grapefruit size

When you begin to throw, you'll find that the clay can quickly go to waste as you work, and a bowl might end up being a cup instead. It's always a good idea to start out with a little more clay than you expect to use.

Centering the Clay

Tools and Accessories:
Sponge
Large bowl of water
Apron

Centering is a technique for setting the clay in the middle of your wheel. The technique involves shaping the clay into a ball and then pressing it down again. It sounds easy, but it can take time to learn. The best approach is to practice, have patience, and then you'll get it!

When you are centering clay for a bowl, you should press the clay into a ball one or two times. For a beginner, it might take five or six times or more. When throwing large items, you'll need more clay, so you'll need to press the clay more times for it to be centered.

Centering is the most important skill to learn for throwing because it affects the rest of the process. When the clay is centered, there is less risk of it becoming crooked as you throw.

Don't forget to dip your hands in water several times as you work. It makes the process much easier!

2

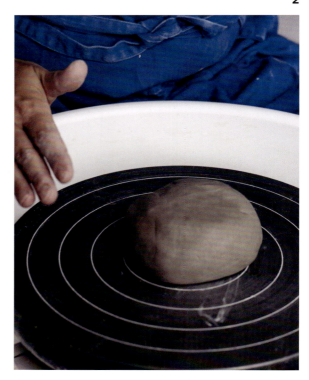

1 Knead the clay.

2 When you start throwing, it's important that the wheel be clean and dry. If there are bits of clay on the wheel or if it is wet, the clay will slide off. Take the clay and throw it down hard on the center of the wheel or as close to the middle as you can. If it isn't sitting precisely, you can carefully nudge it into place at the center with your hands before you begin. Sit close to the wheel, preferably at a comfortable height so you can use your own body weight to guide and press the clay easily when you center it. Sit bent forward over the wheel and hold your elbows close to your body for the best control over centering.

Adjust the wheel for either left-handed or right-handed. If you are right-handed, the wheel should turn clockwise. If you are left-handed, it should spin counterclockwise. All the examples in this book are shown for right-handed people.

3 When you throw, it is important for the clay to be wet so it can glide easily in your hands. You should moisten your hands and the clay many times as you work. You can also have a wet sponge in one hand while you throw. Try out various methods and see what works best for you.

Begin by moistening your hands. Set the wheel to its highest speed. Press slightly in and down on the clay with both hands until it begins to cohere. The clay should not become flat, only even and round. The clay will feel uneven and shaky at first. This is totally normal.

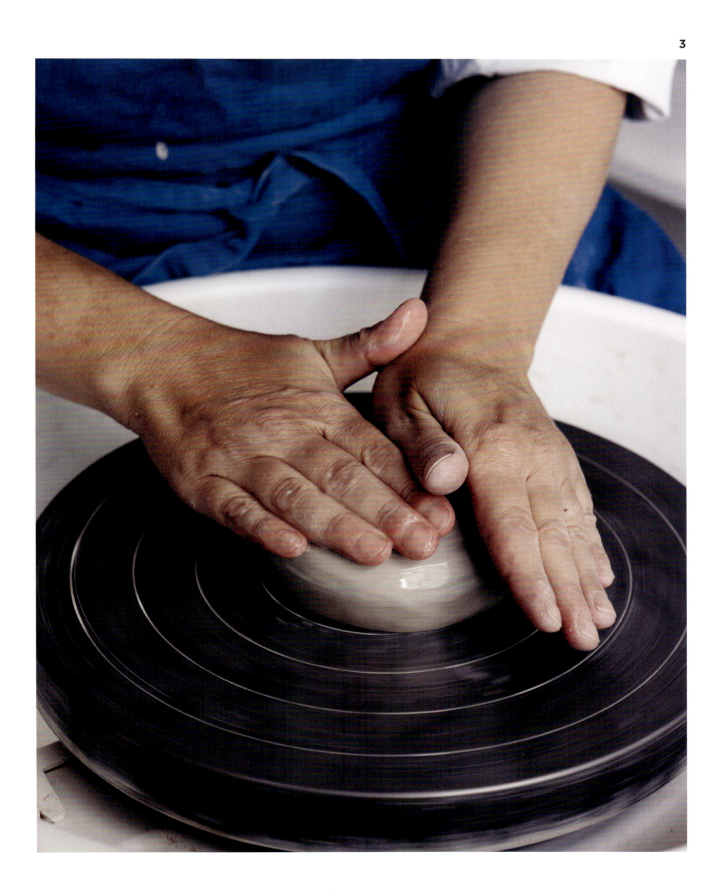

4 Now you can begin centering. Don't forget to put water on your hands. Begin by pressing the clay up into a cone shape. Press with both hands on the side of the clay and press it upward. Hold your elbows into your body. A depression might appear in the middle of the cone in the meantime. This is because you are pressing too quickly. You can fix that when you press down again.

5 When your piece is high and cone shaped, you should press it down again. Don't forget the water on your hands. Press down with your left hand on top of the cone and support the right side with your right hand. Hold your right arm into your body to maintain control over the clay.

6 Repeat the process. If it feels crooked and shaky, it is still not centered. It will be centered when it feels completely even and as if it is standing still even when it's turning around. As a general rule, centering should be repeated several times. The more clay you use, the more times you need to repeat the centering process. Shape the clay into a large cylinder. This is a good basic shape to continue throwing from, no matter what item you are throwing.

Throw a cup, bowl, plate, pitcher, or vase. See page 51.

4

5

Throw a Cup

Throw a Cup

Dimensions for a cup before firing:
3⅛ in. (8 cm) high x 4 in. (10 cm) wide

Dimensions for a cup after firing:
2¾ in. (7 cm) high x 3¼ in. (8.5 cm) wide

Clay:
Porcelain

Weight:
0.55 lb. (250 g)

Tools and Accessories:
Potter's needle
Sponge
Flat modeling stick
Rib
Craft knife
Ruler
Cutting wire
Large bowl of water
Apron

In this section, we'll show you how to throw a cup. This cup is thrown with porcelain clay because that is a fine choice for a cup and because, for a beginner, it is easiest to throw small items with porcelain.

Porcelain clay feels very soft and is nice to throw with. It is perfect for small items, which don't take much time to throw. The clay quickly becomes wet and can become too soft to throw, so it can be more difficult to throw larger items with it before you are more experienced at throwing.

Keep in mind that porcelain shrinks about 15 percent. The cup will be much larger when you throw it than when it is a finished cup.

Later in the book, we'll show you how to attach a handle to your cup. The handle is also made of porcelain. It has a twisted handle, shown in the examples on page 115, which adds character and an edge to your cup's simple shape.

Before you begin to throw a cup, it's a good idea to consider what shape you want to produce. Should it be a tall mug or a wide cup? Should it have a handle on it? And how do you want to place the handle? When you know all that, you can more easily throw following your decisions.

1 Knead the clay (see page 35).

2 Take the clay and throw it down in the center
 of the wheel. Begin by centering the clay
 (see page 43).

3 Once the clay is centered, you can begin
 throwing the body of it. Start at two-thirds
 speed on the wheel. Don't forget the water on
 your hands. With your left hand, support the left
 side of the clay while you slowly press down in
 the center of the clay with your index finger or
 thumb. Press down in the center of the clay until
 you are about ⅜ inches (1 cm) from the base. Use
 the potter's needle to measure the thickness of
 the base. Remember the water for your hands.

4 With your right index finger, slowly pull the clay
 outward so the opening becomes larger. Pull out
 at the same time as you support the left side
 with your left hand, so the base doesn't widen
 too quickly. The base should be about 4 inches
 (10 cm) wide on the outside. Pull out two or
 three times on the base. This might create some
 ridges or a spiral form on the base. You can even
 them out carefully with your fingers or a sponge
 for a flat and smooth surface.

5 Now you will raise the clay up. Place your left
 hand in the shape with your left index finger on
 the inside. If you imagine the clay as a clockface,
 it will be at 3:00 on the clay. Place your right
 hand with your index finger bent on the outside,
 straight on the other side of the clay, so your
 finger follows up. We think you'll best support
 the clay by using the side of your index finger
 to push the clay up, but you could also use the
 top of your index finger or a sponge. Try various
 ways and decide what works best for you.

3

4

6 Begin by pressing the clay carefully from the bottom and up, so all the clay goes up and it doesn't go to waste at the base. Press on the outside with your right index finger and support the inside with your left index finger. Do this slowly, two or three times. Shape the cup as a small cylinder, about 4 inches (10 cm) wide and 3⅛–3½ inches (8–9 cm) high. Take the sponge and carefully wipe off your cup so you can see the shape better and to prevent it from having a lot of excess water and clay on it.

7 Lower the wheel speed somewhat. Use the next pull to refine the sides of the cup. Press on the inside with your left index finger and support the outside with your right index finger. Press from the bottom up. Do this slowly, one or two times. Make sure that the clay doesn't become too thin at the bottom and too thick at the top. Try to produce an even thickness all around the cup sides. The thickness of the cup should be ¼–⅓ inch (0.5–0.8 cm). The height of the cup can vary depending on how thick the cup is.

8 When the cup is the right shape and size, you can straighten the rim. With your left thumb and index finger, carefully hold the rim of the cup. Lay your right index finger carefully on top of the rim and squeeze the rim to the thickness you want and then round the rim.

9 When the height and rim are fine, you can wipe the cup off. Carefully wipe the whole cup with the sponge so that no water or clay residue is on the cup. If you want a smooth side on the cup, you can use the rib. Hold it in on the side of the clay and scrape until the side is completely sharp.

6

7

8

9

10 Before you cut your cup off the wheel, you can
 take a modeling stick and scrape a little off the
 rim at the base of the cup. A little extra clay
 can easily collect at the base, and it's better to
 remove it now than when the cup is cut off later.

11 Take the craft knife and place it ¼ inch
 (0.5 cm) under the cup. This makes it easier to
 draw the cutting wire in under the cup when you
 cut it loose.

12 Stop the wheel. Pour a little water onto the wheel
 in front of and behind the cup. The water will
 help the cup glide off the wheel more easily. Hold
 the cutting wire completely down against the
 wheel with both thumbs and pull it in under the
 cup toward you. If the cup doesn't slip off the
 wheel the first time, you can repeat this step.

13 Clean any clay residue off your fingers before
 you carefully move the bowl over to a plaster-
 board where it can dry. If your cup was pushed in
 a little or was slightly damaged when you moved
 it, you can fix it carefully.

 Set the cup to dry. See page 163.

 Attach a handle to the cup. See page 115.

 *Don't forget to trim the cup before you attach the
 handle. See page 140.*

10

11

12

13

Throw
a Bowl

Throw a Bowl

Dimensions for a bowl before firing:
3 in. (7.5 cm) high x 5¾ in.
 (14.5 cm) wide

Dimensions for a bowl after firing:
2½ in. (6.5 cm) high x 5⅛ in.
 (13 cm) wide

Clay:
Stoneware

Weight:
0.77 lb. (350 g)

Tools and Accessories:
Potter's needle
Sponge
Flat modeling stick
Rib
Ruler
Cutting wire
Bowl of water
Apron

In this section, we'll show you how to throw a low, wide bowl. The bowl is thrown with stoneware, which is light brown and will add some small decorative spots.

Before you begin, you should decide on what type of bowl you want to make. Should it be low and wide, or should it be high? Will you use it for eating breakfast or for serving?

3

1 Knead the clay (see page 35).

2 Take the clay and throw it down in the center of the wheel. Begin by centering the clay (see page 43).

3 Once the clay is centered, you can begin throwing the bowl. Start at two-thirds speed on the wheel. Don't forget the water on your hands. With your left hand, support the left side of the clay while you slowly press down in the center of the clay with your index finger or thumb.

4 With your right index finger, slowly pull the clay outward so the opening becomes larger. Pull out at the same time as you support the left side with your left hand, so the base doesn't widen too quickly. The base should be about 4 inches (10 cm) wide. Pull out two or three times on the base. This might create some ridges or a spiral form on the base. You can even them out carefully with your fingers or a sponge for a flat and smooth surface.

5 The base should be about ⅜ inch (1 cm) thick. Use the potter's needle to measure the thickness of the base.

4

6 Now you can shape the sides of your bowl. Place your left hand into the shape with your left index finger on the inside. If you imagine the clay as a clockface, it will be at 3:00 on the clay. Place your right hand with your index finger bent on the outside, straight on the other side of the clay, so your finger follows up.

Carefully press the clay from the bottom upward so all the clay moves up and it won't collect at the base. With the side of your right index finger, press on the outside and support the inside with your left index finger. Do this slowly, one or two times. Shape the bowl into a little cylinder to begin with, about 4 inches (10 cm) wide and 2 inches (5 cm) high. Use the sponge to carefully wipe off the bowl so you can see the shape better and to avoid excess water and clay sitting on it.

7 Slow the speed a bit. Use the next movements to refine the sides of the bowl. With the side of your left index finger, press on the inside and use your right index finger to support the outside. Press from the bottom and up. Do this slowly, one or two times. Make sure that the clay doesn't become too thick at the top. The height can depend on how thick you want the sides of the bowl to be. If it is over ⅝ inch (1.5 cm), you can press it upward once more or you can pull it out wider. The bowl should be about ¼–⅜ inch (0.5–1 cm) thick. The diameter at the top of the bowl is about 5¾ inches (14.5 cm).

8 When the bowl is the right shape and size, you can straighten the rim. With your left thumb and index finger, carefully hold the rim. Lay your right index finger carefully over the rim and pinch the rim to the thickness you want. Carefully wipe the entire bowl with the sponge so no water or clay residue is on it.

6

7

9 Before you cut the bowl off the wheel, you can take your modeling stick and scrape a little off the rim at the base. A little extra clay can collect at the base, and it's better to remove it now than when the bowl is cut off later. Insert the craft knife ¼ inch (0.5 cm) in under the bowl. This makes it easier to draw the cutting wire in under the bowl when you cut it loose.

10 Stop the wheel. Pour a little water onto the wheel in front of and behind the bowl. The water will help the bowl glide off the wheel more easily. Hold the cutting wire completely down against the wheel with both thumbs and pull it in under the bowl toward you. If the bowl doesn't slip off the wheel the first time, you can repeat this step.

11 Clean any clay residue off your fingers before you carefully move the bowl over to a plaster-board where it can dry. If your bowl was pushed in a little or was slightly damaged when you moved it, you can fix it carefully. Wait about five to ten minutes, until the clay is slightly dry.

Set the bowl to dry. See page 163.

Trim the bowl. See page 140.

9

10

Throw a Plate

Throw a Plate

Dimensions for a plate before firing:
1⅜ in. (3.5 cm) high x 10¾ in.
 (27 cm) wide

Dimensions for a plate after firing:
1 in. (2.5 cm) high x 9⅝ in.
 (24.5 cm) wide

Clay:
Stoneware

Weight:
2.43 lb. (1,100 g)

Tools and Accessories:
Potter's needle
Sponge
Flat modeling stick
Rib
Ruler
Cutting wire
Bowl of water
Apron
Plasterboard bat approximately 11¾ in.
 (30 cm) in diameter
Extra clay for plasterboard,
 approximately 0.66 lb. (300 g)

In this section, we'll show you how to throw a large plate on an extra plasterboard disc called a "bat." The bowl is thrown with stoneware. Keep in mind that clay shrinks by about 10 percent, so the plate should be correspondingly larger when you throw it.

If you are throwing a large plate, it'll be too fragile to move directly from the wheel after it has been thrown. For that reason, it would be a big help to use a plasterboard on top of the wheel to throw on. This requires a bit of preparation but will lead to good results when you are throwing large plates.

Placing a Plasterboard Bat on the Wheel

1 Begin by centering ⅔ lb. (300 g) of clay on
 the wheel.

2 Press the clay out on the wheel into a large, flat
 circle. The circle should be about ⅜–¾ inch (1–2
 cm) high.

3 Make a hole in the center down to the wheel
 about 2 inches (5 cm) in diameter, and one more
 ridge on the surface. Make sure that the clay is
 smooth when you lay the plasterboard on top of
 it.

4 Dampen the plasterboard bat with a little water
 and press it down hard on the center of the
 clay circle. Now you can continue with the plate
 on top.

1

2

3

4

3

1 Knead the clay (see page 35).

2 Take the clay and throw it down in the center of the plasterboard bat. Begin by centering the clay (see page 43).

3 Shape the clay into a very large and flat cylinder on the plasterboard bat, approximately 2 x 6 inches (5 x 15 cm). Begin at a high speed. Don't forget to pour water on your hands. Support the clay with your left hand on the left side of the clay while you slowly press down in the center of the clay with your right index finger or several fingers. Press down into the center of the clay until you are about ⅜ inch (1 cm) from the base. If necessary, use a potter's needle to measure the thickness of the base. Don't forget the water on your hands.

4 Slowly pull the clay upward with both hands, to enlarge the opening. Hold the clay down while you pull so it stays in contact with the plasterboard bat while it is pulled up.

4

5 This might be a large surface to pull out with your fingers. If so, interlock your hands and use the back of your hands to press the clay down. It is important that all the clay from the center is pressed down and out so it can be used for the base and rim of the plate.

Press and pull out four or five times on the base. This might make some ridges or a spiral on the base. They can be carefully smoothed out with your fingers or a sponge so the plate will have a flat and smooth base. The base should be about 9½ inches (24 cm) wide.

6 **6**

6 Now you can shape the side of the plate. Place your left hand in the piece with your left index finger on the inside. If you imagine the clay as a clockface, it is at 3:00. Place your right hand with your bent index finger on the outside, straight across on the opposite side of the clay, so your fingers can follow up.

Carefully press the clay from the bottom up all at once so the clay won't collect at the base. With your right index finger, press on the outside and use your left index finger to support the inside. Slowly press again, one or two times. The curve on the inside should be soft and follow the shape externally. The height depends on how thick you want the sides of the plate to be. If you want a higher plate, you can press from the bottom and up an extra time.

This plate is about 1⅜ inches (3.5 cm) high. You could also pull the plate out a little wider by pulling it out more. Note the thickness and make sure there is enough clay and that the clay can hold its shape. The thickness of the side can be from ¼ to ⅜ inch (0.5–1 cm).

7 When the plate has the correct shape and size, you can straighten the rim. Use your left thumb and index finger to carefully hold the rim. Lay your right index finger on top and shape the rim.

8 Use the modeling stick to scrape a little off the base of the plate. A little extra clay can easily collect at the base, and it's better to remove it now rather than when the plate is cut off later.

7

9 Stop the wheel. Now you can ease the
 plasterboard off by holding the modeling stick
 in between the bat and the wheel. This way,
 you'll avoid moving the plate while it is soft.

10 Set the plate to dry. When it begins to slip
 off the disc, you can carefully take it and cut
 it off.

Set the plate to dry. See page 163.

Trim the plate. See page 146.

9

10

Throw a Pitcher

Throw a Pitcher

Dimensions for a pitcher before firing:
4¾ in. (12 cm) high x 5¼ in.
(13.5 cm) wide

Dimensions for a pitcher after firing:
4¼ in. (11 cm) high x 4¾ in.
(12 cm) wide

Clay:
Stoneware

Weight:
1.98 lb. (900 g)

Tools and Accessories:
Potter's needle
Sponge
Flat modeling stick
Rib
Craft knife
Ruler
Cutting wire
Large bowl of water
Apron

In this section, we show you how to throw a pitcher and shape a spout. This pitcher is medium large and is suitable for water or juice. The pitcher is made with stoneware clay, a coarse and dark type of clay that contains a lot of chammote (also called grog, firesand, or fireclay; usually made from crushed and ground potsherds).

Later, we'll show you how you can add a handle to the pitcher.

When you throw a pitcher, it's a good idea to overestimate how much clay you need. Will the pitcher be used for milk and, if so, will it need a handle? Or maybe it will be a large pitcher, and in that case, would a handle be necessary?

1 Knead the clay (see page 35).

2 Take the clay and throw it down in the center of
 the wheel. Begin by centering the clay (see page
 43).

3 Shape the clay into a very large and flat cylinder
 on the wheel. Begin at a two-thirds speed or
 higher. Don't forget to pour water on your hands.
 Support the clay with your left hand on the left
 side of the clay while you slowly press down in
 the center of the clay with your right index finger
 or thumb. Press down into the center of the clay
 until you are about ⅜ inch (1 cm) from the base.
 Use a potter's needle to measure the thickness of
 the base. Don't forget the water on your hands.

4 Slowly pull the clay outward with your right
 index and middle fingers to enlarge the opening.
 Pull outward at the same time as supporting the
 clay with your left hand so that the base doesn't
 become too wide all at once. The base should be
 about 5⅛ inches (13 cm) wide. Pull out from the
 base three or four times. This might make some
 ridges or a spiral on the base. They can be care-
 fully smoothed out with your fingers or a sponge
 for a flat and smooth surface.

5 Now you will raise the height of the clay.
 Place your left index finger on the inside. If you
 imagine the clay as a clockface, it is at 3:00.
 Place your right hand with your bent index
 finger on the outside, straight across on the
 opposite side of the clay, so your fingers can
 follow up.

3

4

6 Begin by carefully pressing the clay from the bottom and up, so all the clay goes up and won't collect at the base. With your right index finger, press on the outside and use your left index finger to support the inside. Shape the clay into a cylinder to begin with. Slowly press the side up, about four or five times. The pitcher should be about 4¾ inches (12 cm) high. Use the sponge to carefully wipe the clay to keep the sides from having too much excess water.

7 Lower the wheel speed a little. On your next pull up, refine the sides of the pitcher. Place your left index finger on the inside and your right index finger on the outside. Slowly press from both sides until you have a fine thickness on the sides of the pitcher. Try to maintain a uniform thickness of about ¼–⅜ inch (0.5–1 cm) on the sides of the pitcher.

The shape of this pitcher is straight up and down. Use the rib if you don't want any throwing marks from your fingers to show. Hold the rib vertically on the side of the pitcher and scrape it smooth.

8 Straighten the rim of the pitcher. Carefully hold the rim with your left thumb and index finger. Lay your right index finger on top and shape the rim to be either flat or rounded. Finish by wiping off the whole pitcher with a damp sponge.

9 Before you cut the pitcher from the wheel, you can use a modeling stick to scrape any bits of residue off the base of the pitcher. Place the modeling stick on the wheel and scrape ¼ inch (0.5 cm) off the base.

6

7

8

9

10 Insert the craft knife ⅜ inch (1 cm) in under the
 pitcher. This will make it easier to get the cutting
 wire under the pitcher when you cut it off.

11 Stop the wheel. Pour a little water onto the wheel
 in front of and behind the pitcher. The water will
 help the pitcher slide easily off the wheel. Hold
 the cutting wire right down on the wheel with
 both of your thumbs and pull it, under the pitcher,
 toward you. If the pitcher doesn't slip off the
 wheel the first time, try again.

12 Clean your fingers so they are free of clay residue
 before you carefully move the pitcher over to a
 plate. If your pitcher has a little ding or is slightly
 damaged from being moved, you can carefully
 fix it.

10

11

Spout

You can make a spout right after you've thrown the pitcher, while the clay is still wet and soft.

1 Begin by placing your left index finger and thumb up against the outside of the rim. Moisten your right index finger and carefully slide it diagonally over the rim between your left thumb and index finger. Do this two or three times. Repeat several times, depending on how large the spout will be.

2 Avoid dragging the pitcher out of shape when you pull out the spout. Hold your left thumb and index finger firmly on each side of the spout so only the spout will be pulled on and not the whole pitcher. Be careful when you wipe off the spout with the sponge, or wait until it is leather hard. The spout is very soft and can easily get crooked.

Set the pitcher to dry. See page 163.

Attach the handle to the pitcher. See page 127.

Don't forget to trim the pitcher before you attach the handle. See page 140.

Throw a Vase

Throw a Vase

Dimensions for a pitcher before firing:
6 in. (15 cm) high x 4 in. (10 cm) wide

Dimensions for a pitcher after firing:
5¼ in. (13.5 cm) high x 3½ in.
 (9 cm) wide

Clay:
Stoneware

Weight:
1.98 lb. (900 g)

Tools and Accessories:
Potter's needle
Sponge
Flat modeling stick
Ruler
Cutting wire
Sponge stick
Bowl of water
Apron

In this chapter, we'll show you how to throw a small, wide vase with a narrow neck. It will nicely hold a small stem with flowers. The vase is light brown stoneware.

Before you throw a vase, you should consider whether you want it for a small branch, a single flower, or a whole bouquet.

3

4

1 Knead the clay (see page 35).

2 Take the clay and throw it down in the center of the wheel. Begin by centering the clay (see page 43).

3 Shape the clay into a very large cylinder on the wheel. Begin at a two-thirds speed. Don't forget to pour water on your hands. Support the clay with your left hand on the left side of the clay while you slowly press down in the center of the clay with your right index finger or thumb. Press down into the center of the clay until you are about ⅜ inch (1 cm) from the base. Use a potter's needle to measure the thickness of the base. Don't forget to water your hands.

4 Slowly pull the clay outward with your right index and middle fingers to enlarge the opening. Pull outward at the same time as supporting the clay with your left hand, so that the base doesn't become too wide all at once. The base should be about 2¾–4 inches (7–10 cm) wide. Pull out from the base three or four times. This might make some ridges or a spiral on the base. They can be carefully smoothed out with your fingers or a sponge for a flat and smooth surface.

5 Now you will raise the height of the clay. Place your left hand inside the opening with your left index finger on the inside. If you imagine the clay as a clockface, it is at 3:00. Place your right hand with your bent index finger on the outside, straight across on the opposite side of the clay, so your fingers can follow up.

6

6 Begin by carefully pressing the clay from the bottom and up, so all the clay goes up and won't collect at the base. With your right index finger, press on the outside and use your left index finger to support the inside. Shape the clay into a small cylinder to begin with. This is a good basic shape to work with. Slowly press the side up, two or three times, until it is about 3¼–4 inches (8–10 cm) wide and 4 inches (10 cm) high. Use the sponge to carefully wipe the clay so you can see its shape and to keep the sides from having too much excess water.

7 Lower the wheel speed a little. On your next pull up, shape the sides of the vase. Press with your left index finger on the inside and add support with your right index finger on the outside. Slowly press from the outside to the inside until the vase has a fine curve. Carefully repeat this step two or three times. Make sure that the clay doesn't become too thin at the bottom and too thick at the top. Try to maintain a uniform thickness of about ⅝ inch (1.5 cm) on the sides of the vase. Also make sure that the top part isn't pressed out too much, since it will be narrowed later. If the clay is pressed out too far, it can be difficult to narrow it again because the clay gets wet and soft as you work.

7

8 If the top is too high or thick for it to hold its shape, you can cut a bit of it off. Turn the speed all the way down. Carefully insert the craft knife halfway in on the outer side, about ⅜ inch (1 cm) from the top or where the neck will be. Use your left index finger to support the inside of the rim. When you are almost at the rim with your craft knife, you can stop the wheel and carefully pull it loose.

9 When shaping the neck of the vase, begin by carefully pushing in with both hands. As the clay becomes pressed together, it will be a little thicker at the top. You can take advantage of this to add a little height to the neck of the vase. As the clay thins, turn the speed down.

10 Once the curve at the side is as you like, you can carefully wipe the inside with a sponge so there won't be any water or clay residue at the base. As you begin narrowing the top of the vase's neck, you will no longer be able to insert your hand into the vase. So, you can use a sponge stick to absorb the last of the water when you are finished with the vase.

11 When the opening is too small to stick your hand inside the vase, you can use your left index finger on the inside and right index finger on the outside. Your two fingers will be next to each other, with the clay in between. Carefully press the clay in and up with both fingers in a few pulls while you finesse the neck of the vase. Set the wheel speed to low. Make sure that the curve in the clay doesn't get too thin.

9

10

12 To finish, smooth the rim. Hold the rim carefully
 with your left thumb and index finger. Carefully
 place your right index finger on top of the rim.
 Pinch the rim with your two left fingers and
 adjust the rim with your right index finger until
 it is flat or rounded. Use the sponge to carefully
 wipe the vase, to remove any remaining water or
 clay residue.

13 Before you cut the vase from the wheel, you can
 use a modeling stick to scrape any bits of residue
 off the base of the vase. A little extra clay might
 collect at the base, and it's better to remove it
 now than when the vase will be cut off.

14 Insert the craft knife ¼ inch (0.5 cm) in under the
 vase. This will make it easier to get the cutting
 wire under the vase when you cut it off.

15 Stop the wheel. Pour a little water onto the wheel
 in front of and behind the vase. The water will
 help the vase slide easily off the wheel. Hold the
 cutting wire right down on the wheel with both
 of your thumbs and pull the wire under the vase
 toward you. If the vase doesn't slip off the wheel
 the first time, try again until it slides off.

16 Clean your fingers so they are free of clay residue
 before you carefully move the vase over to a
 plate so it can dry. If your vase has a little ding or
 is slightly damaged from being moved, you can
 carefully fix it. Wait about five to ten minutes until
 the clay has dried slightly.

Set the vase to dry. See page 163.

Trim the vase. See page 152.

12

13

14

15

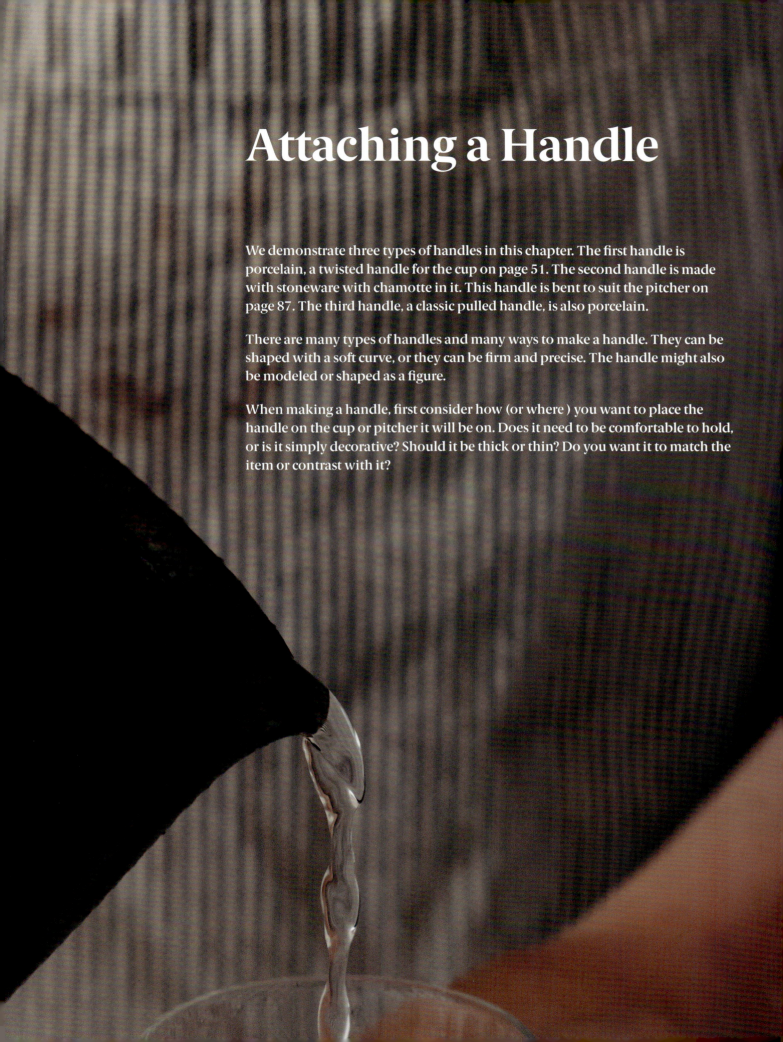

Attaching a Handle

We demonstrate three types of handles in this chapter. The first handle is porcelain, a twisted handle for the cup on page 51. The second handle is made with stoneware with chamotte in it. This handle is bent to suit the pitcher on page 87. The third handle, a classic pulled handle, is also porcelain.

There are many types of handles and many ways to make a handle. They can be shaped with a soft curve, or they can be firm and precise. The handle might also be modeled or shaped as a figure.

When making a handle, first consider how (or where) you want to place the handle on the cup or pitcher it will be on. Does it need to be comfortable to hold, or is it simply decorative? Should it be thick or thin? Do you want it to match the item or contrast with it?

Clay:
Porcelain, the same clay as for the cup

Weight:
Approximately 7 ounces (200 g)

Tools and Accessories:
Sponge
Modeling stick
Craft knife
Metal rib
Cutting wire
Porcelain slip
Bowl of water
Brush

Twisted Handle for a Cup

For this cup, we decided to make a twisted handle for a fine contrast with the simple cup.

When making a handle, the clay should be the same as for the main item, so the clays will meld and shrink at the same rate.

Keep in mind that porcelain shrinks about 15 percent when it is fired. So that the handle will fit around your hand or some fingers, you need to take that into consideration and make the handle correspondingly larger.

Don't forget to trim the cup before you attach the handle (see page 140).

1 Begin by rolling the porcelain clay into two
 "sausages, about 6 inches (15 cm) long and
 ⅜ inch (1 cm) thick.

2 Twist the two pieces around each other and
 bend them into the shape desired for the handle.

3 Use a wet brush to keep the surface moist and
 smooth.

1

2

4

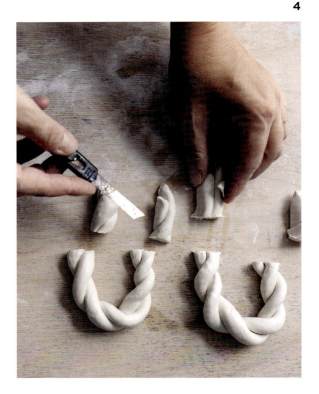

4 Trim the ends.

5 Hold the handle up to the cup. Don't forget
 that the clay will shrink by about 15 percent.
 Once you've decided on the size and shape, you
 can leave the handle to dry. Lay it on its side,
 preferably on a piece of newspaper. Cover it
 with plastic so it won't dry too quickly. Partway
 through the drying, turn the handle over so it will
 dry on both sides. Check to make sure it doesn't
 tear. Use a wet brush to keep the surface even.

6 When the handle is firm and stable enough to
 hold its shape, you can continue. Check the ends
 to make sure they match up with the side of the
 cup. Scrape the ends with a metal rib and dab
 slip on them.

5

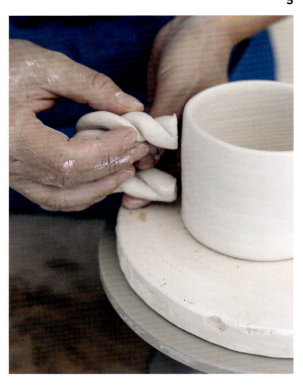

7 Mark the two places on the cup where the handle will be attached. Scrape the two spots with the metal rib.

8 Dab the two spots with slip.

9 Press the handle in on the cup. First firmly press the top so it sits securely, and then firmly press on the lower part of the handle. The handle will sit a bit unevenly because it is made with two "sausage" logs. You can adjust this by rolling out two thin (⅛ inch) logs and laying them around each end of the handle.

10 Mash clay into the slip mixture and rub it well so the handle and cup are firmly joined. Use the modeling stick or your fingers to do this. Adjust the joins so they are fine and smooth.

7

8

9

10

11 Be careful that the handle doesn't become too dry as you work. Porcelain dries out quickly and can easily break. Keep it moist and smooth with water on a brush. Finish by carefully wiping off the cup and handle with a sponge.

12 As needed, support the handle with clay or paper, so it won't hang down and become crooked as it dries. Cover the handle with some extra plastic while the cup dries. It is thin and fragile and should not dry out more quickly than the rest of the cup.

Set the cup out to dry. See page 163.

Slip

Slip is a soft, sticky slurry consisting of clay and water. It functions a bit like glue when you are joining pieces like, for example, a handle on a cup.

You can make slip quickly by taking some completely dry clay and breaking it into small pieces in a bowl.

Pour in water and let it sit for five to ten minutes. Stir it occasionally so it becomes creamy and thick. It should have about the same consistency as thin sour cream.

Don't forget that you should always use the same type of clay for your items and the slip.

Clay:
Stoneware, the same clay as for
 the pitcher

Weight:
Approximately 7 ounces (200 g)

Tools and Accessories:
Sponge
Modeling stick
Craft knife
Metal rib
Ruler
Cutting wire
Rolling pin
Stoneware slip (same clay as
 for pitcher)
Bowl of water
Brush
Rotating stand

Handle for a Pitcher

We decided to make this version a simple handle
to match the simple shape of the pitcher. When
making a handle, the clay should be the same as for
the main item, so the clays will meld and shrink at
the same rate.

Keep in mind that clay shrinks about 10 percent
when it is fired. Hold the handle up to the pitcher
and see if it has room for your fingers. If the handle
fits around your hand or some fingers, you need to
take that into consideration and make the handle
correspondingly larger.

Don't forget to trim the pitcher before you attach the
handle (see page 140).

1 Begin by rolling the clay out into a thick log,
about 6 inches (15 cm) long. Carefully roll the
log out with the rolling pin until it is flat, about
⅜–⅝ inch (1–1.5 cm) long and at least
1⅜ inches (4 cm) wide.

2 Use the ruler to measure and the craft knife
to cut the clay for a handle. It should be
approximately 1⅜ inches (4 cm) wide x 6¾–8
inches (17–20 cm) long x ⅝ inches (1.5 cm) high.
Remove any extra clay and put it back into the
bag so it won't dry out.

3 Carefully take the strip and bend it into the
desired shape for the handle. Carefully hold the
handle up to the pitcher and ascertain the size of
the handle. Measure the height so you will know
what the maximum height of the handle can
be. For this pitcher, the height is 5 inches (12.5
cm), so the maximum height of the handle is
4½ inches (11.5 cm). (You need to include a little
extra room for attaching the handle onto the
pitcher.)

1

2

4 Bend the handle carefully so that the two bends won't break. Dab a little water on it to prevent the clay from expanding too much. If some tiny splits occur anyway, you can rub some water on them and smooth them out. When the handle is bent to the desired shape, lay it on its side to dry. If necessary, support the handle with, for example, clay balls to hold the handle's shape while it dries. Carefully cover the handle with plastic. Partway through the drying, turn the handle over so it will dry on both sides. Make sure that the handle doesn't dry out too quickly so it won't split. The more plastic the handle is covered in, the more slowly it will dry. This way, you can control the drying process (see page 163).

5 While the handle dries, you can continue with the pitcher. Lay the ruler on the rim of the pitcher and mark the side opposite the spout. The handle should be attached precisely on the side opposite the spout. Mark the spots on the side of the pitcher where the two ends of the handle will be attached. Take the ruler and check to see that the two spots align horizontally over each other so the handle won't be crooked. Use the metal rib to scrape the surface of the two marked spots where the handle will be attached. Scrape about 1⅜ inches (4 cm) in diameter.

6 Use a brush to dab slip on the spots. Slip functions a bit like glue on clay and helps the pieces bind together better. Cover the pitcher with plastic if the handle isn't ready to be put on yet.

7 Make sure that the handle is firm enough to attach to the pitcher. It should be leather hard and firm enough to hold its shape when you work with it. Hold the handle up to the pitcher again and ensure that the handle has enough room for your fingers when you are holding the handle. Don't forget that clay shrinks by about

4

5

6

7

10 percent, so the space between the handle and the pitcher will be smaller when the piece has been fired. Trim the ends of the handle with the craft knife once you've determined the right size. Scrape both ends of the handle with the metal rib and dab slip on each end. Place the pitcher on the rotating stand. When the pitcher is on the stand, you can more easily turn the pitcher without moving it too much.

8 Carefully attach the handle to the pitcher. Press it firmly so it holds in well.

9 Roll out a thin log, about 1/16 inch (2 mm), with the same type of clay and wrap it around each end of the handle. Carefully press the log around the handle edge so that the log adheres well to both pitcher and handle. Use the modeling stick or your fingers to create a smooth junction. If you prefer a sharp and noticeable join from the handle to the pitcher, you can adjust it with the ruler or the rib.

10 Keep the handle moistened with the brush to prevent splits. Finish by wiping off the whole pitcher with a damp sponge. If the handle is soft and might hang a bit, you can add a support under the handle while it dries. This could be a small clump of clay or some wet paper.

11 There is flexibility in relation to when the pitcher is dry. Make sure that the handle doesn't dry more quickly than the rest of the pitcher. If necessary, cover the handle with some extra plastic to slow the drying process.

Set the pitcher out to dry. See page 163.

8

9

Clay:
Porcelain

Weight:
Approximately 7 ounces (200 g)

Tools and Accessories:
Sponge
Ruler
Craft knife
Bowl of water

Pulled Handle for a Cup

For this version of a cup handle, we decided to show how to pull a handle. This type of handle can be used for either a cup or a pitcher; only the sizes are different.

When pulling a handle, the clay should be the same as for the main item, so the clays will meld and shrink at the same rate. Keep in mind that porcelain shrinks about 15 percent when it is fired.

Don't forget to trim the cup or pitcher before you attach the handle (see page 140).

1 Begin by rolling the clay out into a thick log, about 4 inches (10 cm) long. Grab one end of the log with your left hand and hold it down vertically. Completely moisten your right hand. Grasp the top of the log and slide your hand down while you squeeze uniformly and lightly on the clay all the way down. Just press lightly and softly so the clay won't split or get too thin. Use plenty of water and repeat the process several times. The log should get thinner and longer with each pull.

2 Stop when the log is the thickness you want for the handle. It should be about 6–8 inches (15–20 cm) long and ¾–1¼ inches (2–3 cm) thick. It will be thicker at the top than at the bottom. That doesn't matter, since it will be cut later.

3 Now form the log into the shape you want for the handle. Bend it carefully so it has a soft and round form.

4 Leave the handle alone and let it dry slowly. When clay is thin and has a large surface, it dries quickly. If necessary, lay some plastic over it so the clay won't dry out too quickly. Continue, working from step 4 of the twisted handle on page 118.

1

2

3

4

Trimming

Tools and Accessories:
Loop tool
Sponge
Rib
Clay balls
Bowl of water

Trimming is the step in pottery throwing when you scrape excess clay from the bottom of the piece and form the base. Once the piece is leather hard, you can trim it.

There are several methods for trimming pottery. The method you use is determined by what the base will look like. The base can be flat with straight or rounded corners. It could also be trimmed to a smaller circle so the base is raised and your pot will have a little foot, which can be high or low depending on how thick the base of your pot is.

You can also make a foot ring. A foot ring is produced by scraping off clay in a circle on the base so it is a thick ring. This is the most used model because you are removing the excess clay from the base.

We will show you the various steps for trimming. We have chosen different bases for the items in the book so we could show different looks.

Before You Trim

If the clay is extra thick and the rim of the base is uneven on your pot, it will be easier to scrape off some of the clay before you trim on the wheel. Scrape off most of the excess and shape the base into an approximate circle before you begin trimming.

Trimming a Bowl, Cup, and Pitcher

1 Before you trim, center the piece on the wheel. You can use the circles on the wheel to help with centering. Set your piece top down on the wheel, as closely aligned with the circle as possible.

2 Start the wheel at a low speed. Place your left hand over the base and your right hand lightly on the right side without pushing the piece. When trimming your pot, make sure it is centered. It will feel crooked and imprecise until it sits in the center. Look for any crookedness and give your pot a slight nudge at that point. When you've nudged it a little, it should move so it is more closely centered. This takes a bit of practice. You'll know when your pot is centered when it no longer feels uneven. Once you've centered the piece, you can stop the wheel. Place three small clay balls at the rim around your pot so it won't move while you trim it.

3 Start the wheel at medium speed and use the loop tool to scrape clay off the base. Remove only a little at a time. Begin by scraping the base flat. Now you can see where your base will be. Take the loop tool and see where the base ends. If you want a flat base with rounded sides, you can scrape a little off the side so the base and side have a round transition.

1

2

4 If you want this type of base for your pot, wipe it off with a damp sponge.

5 If you want a foot on your pot, you can outline a circle on the base where the foot will be. Scrape the clay carefully off the side of your pot. Hold your left hand on the base and, if necessary, support it with the thumb on your right hand. It is easier to control the loop tool and control the trimming when your hands touch each other. Scrape the clay off the side and up to the outlined circle. Scrape a little extra off the outer side of the circle so you can sense the height of the foot. The more you scrape off, the higher the foot will be.

6 If you want this base, wipe it off with a damp sponge.

7 If you want a foot ring for your pot, you can outline a circle in the center of the base. Scrape the clay away inside the circle. Scrape only $\frac{1}{16}$–$\frac{1}{8}$ inch (2–3 mm) off, unless the base is thick enough to take more off. If the loop tool leaves many ridges, you can use the rib to smooth them away. Finish by wiping off with a damp sponge. Take your pot off the wheel and clean the top where the clay balls were placed.

Add your signature to the base. See page 159.

Leave the pot to dry. See page 163.

4

5

6

7

Trimming a Plate

If you've thrown a plate on a plasterboard bat, it might stick before it is slipped off. You can help it a little by lifting it a bit all around the rim before it slides. Carefully take it off the bat when it has slid off. The center might still be very soft.

Before you trim the plate, you need to check its firmness very carefully. The plate should be firm enough that you can scrape clay off the base. Even if the plate is leather hard and firm, it could possibly sink in the middle while you trim it, because it has a large surface without support underneath. Roll a small clay log to the same thickness as the space between the wheel and the plate and lay it in a circle under the plate. This will support the base so it won't bow or split as you trim.

Tools and Accessories:
Loop tool
Sponge
Rib
Clay balls

1 Place the plate top down on the wheel, with a support under the surface. Start the wheel at medium speed. Use the circles on the wheel to help with centering. Center the plate by gently nudging it in place a little at a time. Place three small clay balls at the rim to hold the plate in position. Begin by scraping the base flat and even with the loop tool.

2 Now determine how big the base should be. Use the loop tool to outline where the base will be. You can scrape down a little around the edge of the plate if there is space. It depends on how high the edge is and how much room the clay balls take up. Shape the transition from the base to the side. If you have a straight edge, you can use the rib. If the edge is round, you can use the loop tool to shape a curve. If you want this edge, wipe the piece off with a damp sponge.

3 You can also form a low foot by scraping more clay off up to the circle that you outlined on the base. The height of the foot depends on how thick the plate is and how thick the base is. When the plate is ready, wipe it off with a damp sponge.

4 If the plate has a thick base, you could also make a foot in the base. Outline the area on the base and scrape the clay from the inner circle, about $\frac{1}{16}$–$\frac{1}{8}$ inch (2–3 mm).

5 If the plate is large—over 8 inches (20 cm) in diameter—you can make an extra foot ring in the middle of the base. This will support the base and prevent the plate from sinking in later during the glaze firing.

2

3

4

5

6 If the loop tool leaves many ridges, you can use the rib to smooth them away. Finish by wiping the plate off with a damp sponge, so the surface is smooth and free of clay residue. Carefully remove the plate from the wheel and wipe off the rest of the plate with the sponge.

Add your signature to the base. See page 159.

Leave the plate to dry. See page 163.

Trimming a Vase

Once the vase is leather hard, you can trim the base. However, it can be difficult to trim the base if your vase is shaped so it can't stand on its head (as the vase shown here). For this type of vase, you can use a support to place the vase into while you trim it.

Tools and Accessories:
Loop tool
Sponge
Rib
Clay for support

1 Throw a small, wide cylinder on the wheel and let it dry a little. Alternately, you can use something already on hand that you can firmly set on the wheel and secure with three small clay balls.

2 Set your vase, top down, into the cylinder. If necessary, cover the lower part with fabric or plastic so the vase won't stick to the cylinder. Center the vase as precisely as possible in the cylinder so it will be easy to center.

3 Start the wheel at low speed. Place your left hand on top of the base and your right hand lightly on the right side, without pushing on the vase. When trimming the vase, make sure it is centered. It will feel crooked and uneven until it is centered. If you notice any crookedness, gently nudge the vase a little at a time so it moves more closely to the center. This takes a bit of practice. You will know that it is centered when it no longer feels uneven.

Adjust the wheel speed to medium and use the loop tool to scrape clay off the base. Remove only a little at a time. Begin by scraping the base flat with the loop tool. Decide where you want the base to be. Use the loop tool to indicate where the base ends. If you want a flat base with rounded sides, you can scrape a little off the side so the base and side will have a round transition.

If you want a thick base, you can scrape the clay away from the center of the base so there is only a narrow edge left on the base. Scrape off only 1/16–1/8 inch (2–3 mm) unless the base is thick enough to take more off.

Wipe the vase off with a damp sponge so the surface is clean and free of clay residue.

Add your signature to the base. See page 159.

Leave the vase to dry. See page 163.

Adding Your Signature

Tools and Accessories:
Ceramic pencil
Brushes
Oxide coloring / underglaze
Stamp

When you've thrown a piece of pottery, a nice detail is adding a signature. It can be your name, your initials, a stamped design, or something else that shows it is your work. You can etch your signature into the clay, stamp it in, or draw it. You can make your signature on the base or on the side—it's up to you.

Once the clay is leather hard, you can easily etch your marking into the clay with a pencil. You could also use a stamp and press it into the clay. If you are using a stamp, press it in carefully. Support the piece with your fingers on the inside so you won't press the clay out of shape. You can use anything from old metal offset book letters to a button with a fine pattern or an actual stamp.

If you want a more professional look, you can make your own logo as a stamp. Stamps can be made with a variety of materials. They can be plastic, wood, or metal. They work best if they are over $\frac{1}{16}$ inch (2 mm) high, so they'll be most obvious when you press down into the clay.

You can also write or draw your signature on your pot after the clay has been fired for the first time. You can draw with underglaze or oxide color. You can also write with a special pencil for ceramics. They function like a regular pencil, but the color won't burn away. You can write on the base when you have glazed your piece and the base is clean.

Choosing Colors and Underglazes

Tools and Accessories:
Clay coloring / underglaze
Oxide coloring
Under- and overglaze coloring

Clay coloring is fine grain clay mixed with water and dye. It is also called underglaze. You can use an underglaze for painting or decorating your pottery, both when it is leather hard and when it has been fired for the first time.

Once your pot is leather hard, you can paint an underglaze onto small or large surfaces. Be careful not to paint too much at a time, because the clay absorbs moisture from the underglaze and will make the clay moist again.

When you are done painting and decorating, leave your piece to dry (see page 163).

You can also paint on your piece after it has been fired the first time. If you have painted something you aren't happy with, you can wash it off and begin again once your pot has dried again.

When you've finished painting or decorating your pottery, you can glaze it. You can also skip glazing if you want a matte and raw surface.

No matter whether you glaze or not, you must fire your pieces a second time (see page 183).

Drying Clay

Tools and Accessories:
Plastic bags
Plasterboard bat
Wooden boards

When you take clay out of its packaging, it slowly begins to dry on the surface. So, it's very important to keep clay well protected in its packaging when it is not in use. Clay dries out because the water vaporizes out of the clay. The more air the clay is exposed to, the more quickly it dries.

When you work with clay, no matter what type of clay, you should also be careful that the clay doesn't dry out too quickly.

If the clay dries too quickly, it can easily crack. Clay dries quickly on thin sections such as edges and handles. These areas especially need to be protected well in the drying process.

The best way to avoid drying is to cover your piece with plastic. The more tightly the plastic fits around your pot, the less water can vaporize out of the clay. You can also lay a damp cloth over your piece, with plastic on top of that, if the clay needs to be kept moist for a longer time.

Clay dries more slowly at the base, which is generally thicker. If your pottery is still too soft at the base and too wet to trim, although the rim is dry, you can dampen the rim with a sponge. Cover the rim with plastic until the base is drier and your piece is uniformly firm.

You could also turn your pot upside down so the base gets more air. Don't forget to cover the rim with plastic so it doesn't dry out too much in the meantime. Make sure that the clay doesn't dry out too much, or it will be too hard to trim.

Leather Hard

As clay dries, it slowly becomes firmer and harder. This is called "leather hard"; that is, when the clay is firm enough to move without losing its shape and, at the same time, soft enough so you can manipulate it and continue working with it. When clay is hardened, it is leathery.

Plastic

There are various types of plastic that you can use to cover clay with. In general, bin bags (not carrier bags or waste bags) are suitable for covering clay. The plastic is soft, so it won't damage the newly thrown soft clay when you pack it in.

Thin plastic bags such as, for example, grocery bags from the supermarket are also good for covering clay. However, that plastic is thin, so, if your pot needs to retain moisture for a longer time, it is best to cover the clay with a thicker plastic.

1 When you have just thrown a pot, it is completely soft and flexible. Therefore, it is best to wait to cover it until it is a bit firmer, about 10–20 minutes. Cover the clay with plastic so the plastic closes tightly around the clay. If necessary, pull the edges down under the plasterboard bat the piece is on. The more tightly you wrap the plastic, the longer the moisture is maintained.

2 When the clay is leather hard, you can trim the base and smooth the rim and surface. You can also continue to work on your pot and attach a handle. If you want to draw in the clay or paint with underglaze, you can do so now. See page 161 for more details.

3 When you are finished with your pot, you can leave it to dry once again. Place it on an underlay that can absorb the moisture from the clay, such as a wooden board or a plasterboard. The pot should still dry slowly with a plastic covering, but the plastic no longer needs to cover the piece so tightly. Lay the plastic loosely over your piece. If the piece has a handle or other thin detail, you can lay plastic a little more tightly over that part.

4 The clay should be completely dry before it goes into the kiln. If it isn't dry, it can break into pieces when it is fired. It can be difficult to discern when it is dry, but if the clay feels cold, it is, as a general rule, still too damp to be fired. The clay also shifts color as it dries. You can usually see that the clay is dry overall when it has the same shade all over the piece. Don't forget to move it carefully when it is completely dry. Avoid lifting it by the handle or in another thin place on your pot, because it is very fragile in those places.

Firing your piece the first time. See page 169.

Firing Clay the First Time

Tools and Accessories:
Ceramic kiln
Oven supports

The first firing is also called a "bisque firing." The clay is fired in an electric ceramic kiln to about 1,742°F (950°C). Once the clay has been fired for the first time, it becomes hard and can't be loosened up again. It is here that the clay goes from being clay to being a ceramic. It won't be watertight or durable enough to use, but it'll be hard enough so it can be glazed.

The clay must be completely dry before it can be fired the first time. For more details on drying, see page 163.

1 When you fill the kiln, you can carefully stack your pieces over each other. Place them closely together and take advantage of the space in the kiln, so you can fire in as environmentally friendly a way as possible. Use the oven supports to build layers in the kiln. The supports should be set in the same place on all layers to provide the best support possible.

2 When you fire the first time, use a slow bisque program setting. Usually, this is the pre-program on the kiln settings. The clay should be fired slowly to prevent splits as the kiln heats up. Cracks in the clay can also occur as the kiln cools down, so, it's best to wait to open the kiln until it has cooled below 212°F (100°C).

Choosing Glaze and Glazing Clay

Tools and Accessories:
Sponge
Glaze
Large spoon
Tub
Pitcher
Large bowl of water
Dust mask

Glazes are liquid materials that you apply to your pieces after they have had their initial, bisque, firing. When the glaze melts in the second firing, it seals the surface of the clay, makes your pottery watertight, and adds a smooth, glossy surface.

Glaze consists of various minerals—primarily chalk, quartz, and feldspar. It comes in powder form to be mixed with water. Glaze powder is dangerous if you inhale it. For that reason, you should always wear a P3-filter dust mask when working with glazes in powder form. Also, make sure your studio is kept clean so you can avoid the health-damaging particles in the glaze dust. Use water to clean the surfaces, and do not sweep or brush the dust away—all you'll be doing is swirling the dust around.

Glazes can be either matte or glossy, and as basic glazes, they are transparent. Glossy glazes are easy to work with. They don't run, and usually they melt uniformly. If the glazes are thicker in a place where they overlap, it likely won't be especially obvious. Matte glazes, however, can produce a milky glow in those places where they overlap or where the glaze is thick.

We recommend the glossy, transparent glazes to begin with, and those are the only kinds we used for this book.

When choosing glazes, you should especially note the melting point and whether the glaze is appropriate for the clay you are using. Usually, this information is on the glaze package, or you can check with the seller.

Glazes are a bit of a jungle because they can be made in so many ways and fired at several different temperatures. For a beginner potter, it is easiest to use the ready-made glazes sold in craft shops. Use the glazes that suit your chosen type of clay. Most stoneware and porcelain glazes have a maximum temperature of 2,336°F (1,280°C), and most ceramic kilns do not burn any higher. Check your local glaze retailer for recommendations.

Glaze with Color

Glazes are available in many different colors, surfaces, and looks. The easiest thing is to buy them already prepared. The seller should have examples of the various types of clay with glazes on them.

You can add color to transparent glazes with pigment colors or oxide colors.

Pigment colors come in powder form and are added to the glaze after measuring. Pigment colors usually remain the same color as in the powder form but in varying tones, depending on how much color you add.

Oxide colors are also in powder form and are mixed the same way. The colors might, however, react differently during firing. They can produce effects, flecks, and patterns, and they can be surprisingly positive or unfortunately negative. It is always a good idea to test a new glaze with a small sample before you glaze something you have spent a long time on.

There are a variety of ways to apply glaze. You can dip it, pour it in or on, or paint it on. You can also spray it on, but that requires some equipment and a spray booth.

Dipping

Dipping produces a very uniform glaze. Because the clay is very dry, it will absorb the glaze when you dip. For that reason, it is very important to dip quickly, about two to four seconds, so the glaze won't be too thick. First dip one side of the piece. When it's dry—this takes about 20–30 seconds—you can dip the other side. The glaze should overlap a little where the glaze dips meet.

Pouring

You can also pour glaze on or in your pot from a pitcher. For example, you can pour glaze inside the cup first. Pour almost up to the rim and then pour the glaze out. If needed, turn your piece at the same time so the glaze spreads all around the inside. You can pour glaze on the outside afterward. If the cup has a foot to hold onto, you can also dip it upside down, with the opening down into the glaze. If you dip the cup perpendicularly, the glaze won't get all the way inside the cup, and a little air pocket will form in the cup when it is glazed.

If you have a large vase, one too big to dip, you can place it on something high in a tub and pour the glaze on. Make sure that the rim is free so the glaze can slide off. Always glaze the inside first so you don't disturb everything too much on the glazed surface afterward. It's very fragile and falls off easily.

Brushing

If there are any small breaks in the glaze or sections without any glaze, you can paint glaze onto those areas. Carefully dab the glaze on. You can also brush the entire surface with glaze, making sure it doesn't go on too thickly or thinly, which can mean an uneven surface. The best thickness for glaze is 0.2–0.4 inches (0.5–1 mm) or about two or three strokes of the brush.

After the bisque firing, the clay will be hard and porous. It usually has a layer of dust on the surface. Begin by wiping it off with a damp sponge. If you want to decorate your pot, you can do so now, before you glaze the piece. (See page 161 for details on color.)

Stir the glaze well until it feels uniform and doesn't have any clumps. The consistency should be something between sweet milk and buttermilk. The glaze quickly sinks to the bottom, so be sure to stir it often. It will feel watery and thin on the top layer after a few minutes.

1 Glaze the inside of your bowl first. Pour the glaze right up to the rim.

2 Pour the glaze out while you turn the bowl, so the entire rim is glazed at the same time. This should be done quickly so that glaze doesn't get too thick.

 If your bowl is very thin, it might be too wet to glaze the outside right away. Let it dry before you glaze the outside.

3 Glaze the outside of the bowl by dipping it straight down into the glaze. You can do this only if you have a foot to hold on to.

4 Thoroughly wipe the glaze off the base and rim of the bowl.

It is critically important that you wipe the base of your pots so they are completely clean of glaze residue. Wipe them off with a wet sponge several times— especially if there are small ridges in the base. The base should be completely free of glaze; otherwise, the glaze will melt quickly during the firing and destroy the kiln shelves, and the base of your piece will be damaged.

1

2

3

4

1

1 Dip one side of your piece into the glaze for about two to five seconds.

2 Dip the other side. Let the glaze overlap the glaze from the first dip, and you can be certain that the entire piece is glazed.

3 Use a rib to scrape the base so it is free of glaze. Scrape any glaze residue into a bowl of water to avoid as much glaze dust as possible.

4 Also scrape the glaze off the rim. If the glaze is very thick, it can run down as it melts in the firing. Some glazes run more than others. Be aware of the melting point for the glaze.

5 Thoroughly wipe the base and rim with a wet sponge several times.

Finally, write or draw your signature on the base of your piece. See page 159.

Do the second firing. See page 183.

2

3

4

5

Firing Clay the Second Time

Tools and Accessories:
Ceramic kiln
Metal blade
Kiln wash for kiln shelves
Waterproof sanding paper
Kiln supports

The second firing is also called a glaze firing. Stoneware and porcelain are fired to approximately 2,192°F–2,372°F (1,200°C–1,300°C). Earthenware is fired to a maximum of 2,012°F (1,100°C).

When the temperature in the kiln reaches the melting point of the glaze, it becomes liquid and melts. So it's important that you know what glaze you are using and that you fire it to the correct temperature. See page 173 for more details on glazes and glazing.

When you fill the kiln with your glazed pottery, you must be sure that no pieces touch each other. If they touch, they will melt together at any point where the glaze touches something else.

If there is any glaze residue or other dirt on the kiln shelves, this can damage the bases of your pottery. Scrape the kiln shelves with a metal blade to remove any residue. If necessary, use a kiln wash on the kiln shelves. If you are unsure if the glaze will run in the kiln, you can fire your pieces on a small bisque-fired clay plate. That way, if the glaze runs, you won't risk it coming out onto the kiln shelves.

When a kiln has fired for a long time, the kiln oven wires/heating elements can become worn out, and eventually the kiln will no longer go up to the desired temperature. If you are in doubt about your kiln firing to the correct temperature, you can use ceramic cones to measure the precise temperature in the kiln. The cones have varying melting points and will melt when they are a specified temperature. For example, a cone for 2,237°F (1,225°C) will completely bend at 2,300°F (1,260°C). And a cone for 2,294.6°F (1,257°C) will begin to lean at that temperature.

1 Divide your pots onto each shelf in the kiln. Divide them so all those on the same shelf are about the same height, so you can use the space most efficiently. Use the kiln supports to build shelves in the kiln. All the kiln supports should be at the same place on each shelf for the best support possible.

2 Use a glaze setting when you fire the second time. Generally, that is a pre-program on the kiln settings. Fractures in the clay can occur during the cooling-down process. This might crackle the glaze if the cool down is too quick or if you open the kiln too soon. So, it is best to wait to open the kiln until it has cooled down to 212°F (100°C).

3 When emptying the kiln, you might find small grains of clay or uneven spots on the base of your pots. You can scrape them off with a metal blade. You can also sand the base and rim, using waterproof sanding paper. That will make the base of your pots feel smooth and fine.

Clay shifts color over the whole process from when it is wet, dry, fired the first time, and fired the second time. It shrinks 10–15 percent depending on the type of clay.

About the Authors

Susan Liebe graduated as a ceramicist from the Danish Design School in 1999. She has designed products for the home, with a focus on ceramics and pottery. In 2008, she started the "Liebe" store in Copenhagen, producing collections of ceramic objects. Today, Liebe's work is sold in several Danish design and interior stores in Denmark and abroad. She is based in Copenhagen. **See more at www.liebeshop.dk.**

Sus Borgbjerg is a graduate of the Danish School of Design, focusing on graphic design. She and her partner, Jette Tosti Ibfelt, founded their design studio, JE;SU Graphic Design, in 2000 for web design, visual identity, concepts, art direction, illustration, packaging, and other graphic design disciplines. She is based in Copenhagen. **See more at www.jesu.dk.**

Other Schiffer Books on Related Subjects:

Lessons with Clay: Step-by-Step Techniques for Colorful Designs in Hand-Thrown and Hand-Built Tableware, Melisa Dora, ISBN 978-0-7643-6469-3

What Makes a Potter: Functional Pottery in America Today, Janet Koplos, ISBN 978-0-7643-5811-1

The Ceramics Studio Guide: What Potters Should Know, Jeff Zamek, ISBN 978-0-7643-5648-3

Designed by JE;SU graphic design, @je_su_graphic_design
Photography: Julie Vöge, Julievoge.dk
Cover design by Lori Malkin Ehrlich
Type set in Gotham Book/Berlingske Serif

ISBN: 978-0-7643-6938-4

Printed in China

Published by Schiffer Publishing, Ltd.
4880 Lower Valley Road
Atglen, PA 19310
Phone: (610) 593-1777; Fax: (610) 593-2002
Email: Info@schifferbooks.com
Web: www.schifferbooks.com

For our complete selection of fine books on this and related subjects, please visit our website at www.schifferbooks.com. You may also write for a free catalog.

Schiffer Publishing's titles are available at special discounts for bulk purchases for sales promotions or premiums. Special editions, including personalized covers, corporate imprints, and excerpts, can be created in large quantities for special needs. For more information, contact the publisher.

We are always looking for people to write books on new and related subjects. If you have an idea for a book, please contact us at proposals@schifferbooks.com.

Acknowledgments:

Thank you to Julie, Jette, Maria, Cecilia, Jesper, and Nina.

Models: Sara, Esther, Mads, Ella, and Metha.

Our sweet families and friends.

Cerama for materials.